Really Impo
My Dog Has Taught Me

CYNTHIA L. COPELAND

WORKMAN • NEW YORK

For the Krause family, who loved Bear as much as we did

Many thanks to my wonderful editor (and fellow dog lover), Margot Herrera, for her insight and ideas, guidance and good humor. She is one of my very favorite people in publishing, and I am always delighted for a chance to work with her. Thanks also to Samantha O'Brien for editorial input, Becky Terhune for design, Michael Dimascio and Anne Kerman for photo research, and Amanda Hong for dotting the i's and crossing the t's.

Copyright © 2014 by Cynthia L. Copeland

All rights reserved. No portion of this book may be reproduced—mechanically, electronically, or by any other means, including photocopying—without written permission of the publisher. Published simultaneously in Canada by Thomas Allen & Son Limited.

Library of Congress Cataloging-in-Publication Data is available.

ISBN 978-0-7611-8179-8

Front cover photograph by John Daniels/ardea.com
Back cover photograph by Shaina Fishman

Additional photo credits appear on page 170.

Workman books are available at special discounts when purchased in bulk for premiums and sales promotions as well as for fund-raising or educational use. Special editions or book excerpts can also be created to specification. For details, contact the Special Sales Director at the address below, or send an email to specialmarkets@workman.com.

Workman Publishing Co., Inc.
225 Varick Street
New York, NY 10014-4381
workman.com

WORKMAN is a registered trademark of Workman Publishing Co., Inc.

Printed in China

First printing October 2014

10 9 8 7 6 5 4

Contents

Introduction • iv

1 **Joy is meant to be shared** • 1

2 **Love is an action word** • 23

3 **It's the challenges that make life interesting** • 45

4 **Strive for just enough** • 65

5 **Be your own champion** • 81

6 **Appreciate life's simple pleasures** • 101

7 **Contribute to the pack** • 121

8 **Let it go** • 139

9 **Every day is the best day** • 149

10 **Age gracefully** • 159

Introduction

I grew up with Dusty, a smart, scrappy border terrier given to my brothers and me by the town librarian, who thought he needed younger playmates. As sweet as he was mischievous, Dusty was the perfect pet for our lively family. Many years later, when I had children of my own, I adopted an energetic mutt from our local shelter. My then-four-year-old daughter, Anya, named him Smokey the Bear—Bear, for short.

For eighteen years, Bear embraced life as a country dog: tangling with porcupines, hiking mountain trails, and cooling off in the neighbor's pond on sticky summer days. He helped herd the sheep and kept our chickens safe from the coyotes. Although he loved to race alongside my daughter as she rode her bike, he was just as happy sitting in the rowboat watching my son fish. In the winter, he joined us for sledding and pond hockey (planting himself directly in

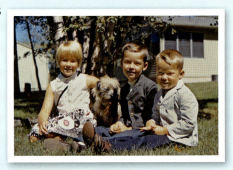

Dusty with my brothers and me, circa 1968

front of me to "protect" me from the puck).

Bear and Anya

When the little girl across the street became confined to a wheelchair, Bear assumed the role of her companion and protector. Often, at night, I'd have to slip into their house where he had dozed off at her side and lure him back home with a treat. Of course when I'd let him out the next morning, he'd trot right back over to her. I believe he is as well represented in their family photo albums as he is in ours.

Bear was more than just a beloved neighborhood dog; he was a daily reminder of how to live a happy life of gratitude and purpose. He took delight in the most mundane events of every day—basking in a ray of sunshine, the occasional table scrap, a vigorous belly rub—and seemed to instinctively know when someone needed his company. We may have taught him to sit and stay and (when he felt so inclined) to roll over, but in the end, what he taught us was of much greater value. I hope you will be inspired by his example and by the special dogs closest to you.

Cindy Copeland

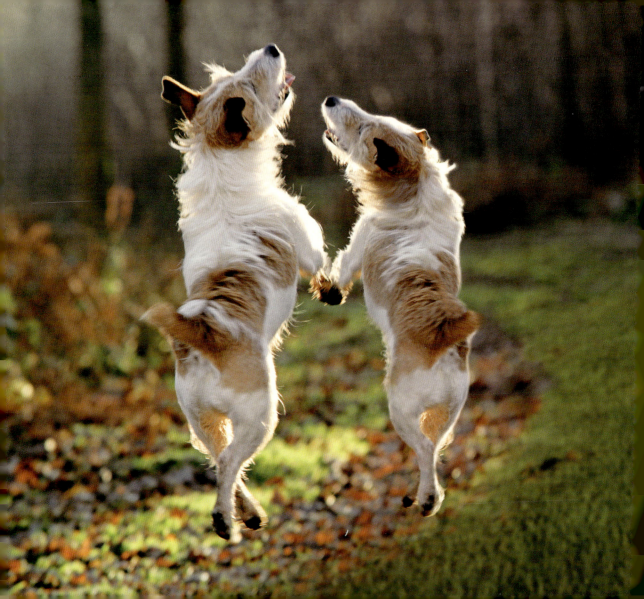

Joy is meant to be shared.

A dog reminds us that happiness is about disposition, not circumstance. He fully embraces every moment of his day, assuming that something wonderful is *just* about to happen. He celebrates what is right and good with the world, overlooking any imperfections. His enthusiasm for even the most seemingly insignificant events is contagious: Someone is at the door! It's time for a walk! I found my ball under the table!

A dog is a living exclamation point!

"The purpose of our lives
—Dalai Lama

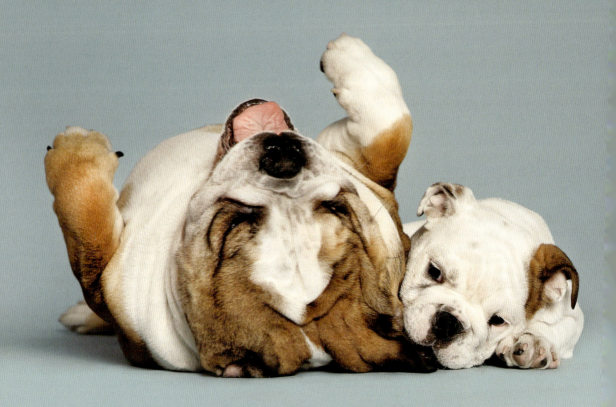

is to be happy."

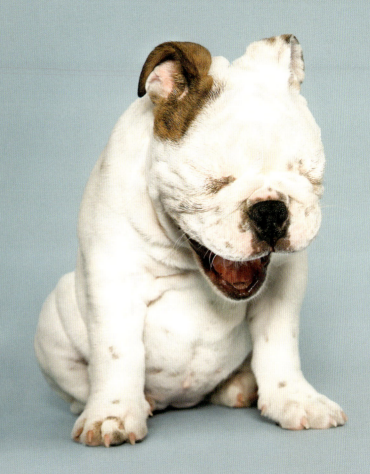

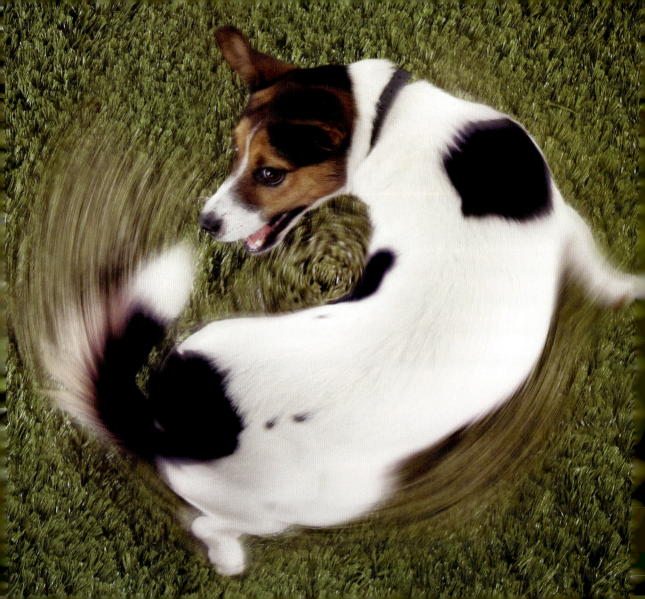

It's not about catching your tail; it's about the fun of chasing it.

Greet loved ones **with enthusiasm** whether they've been gone ten minutes, or ten months.

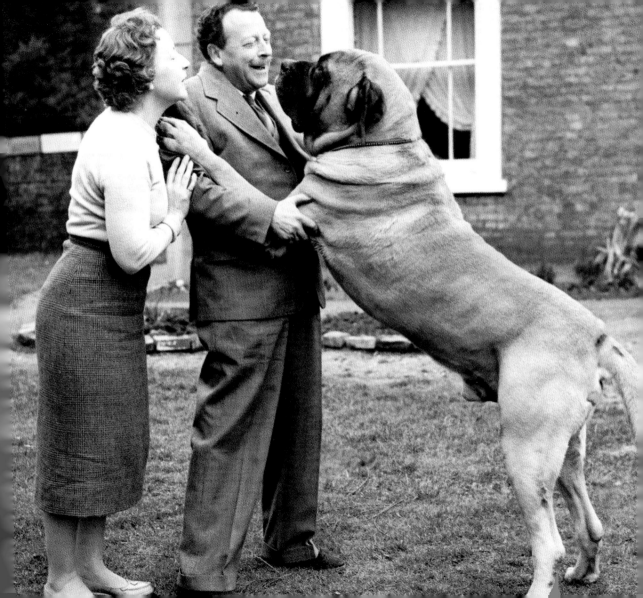

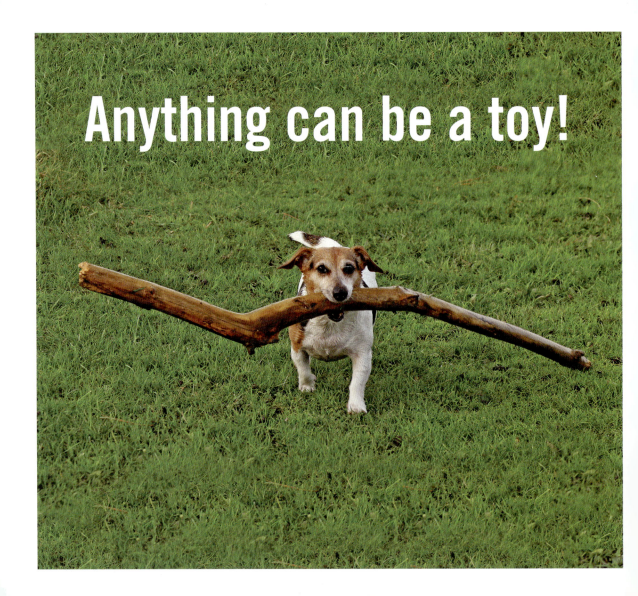

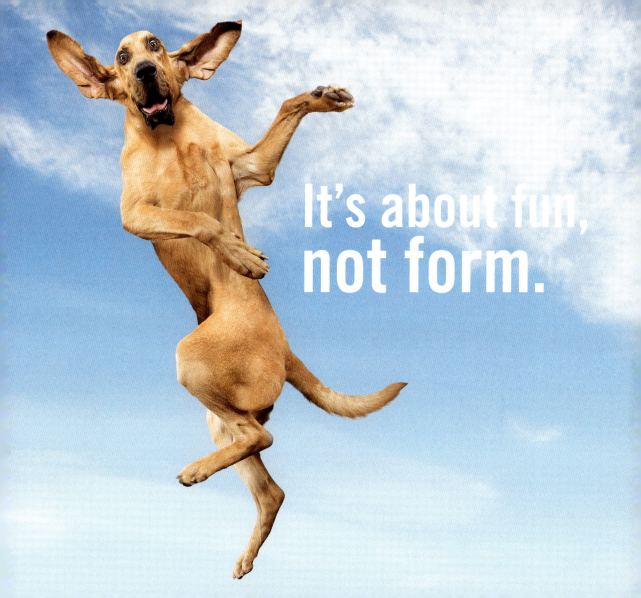

Laugh at yourself. We all have **bad hair days.**

"It is a happy talent to know how to play."
—Ralph Waldo Emerson

3 games for kids and dogs to play together:

Bubbles: Kids love to blow bubbles; dogs love to chase them.

Hansel and Gretel: A child can make a trail of treats (ending with a special treat like a piece of bologna) and see if his dog can follow it!

Hide-and-seek: Instruct the dog to sit and stay while a child hides; if the dog finds the child, he's rewarded with a treat.

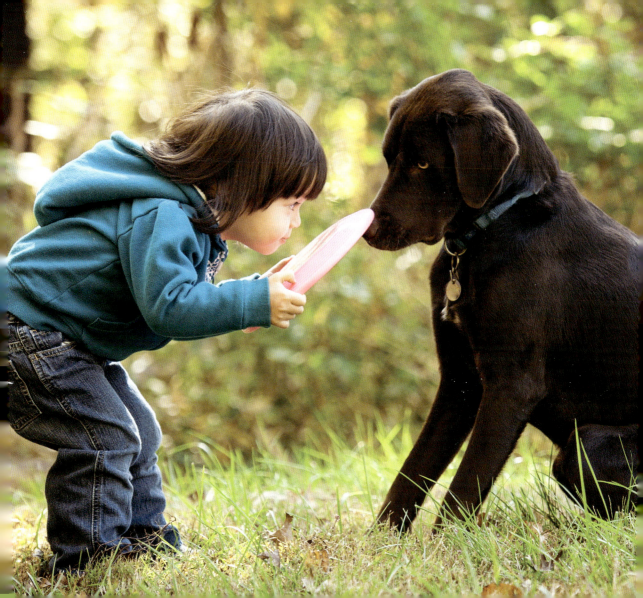

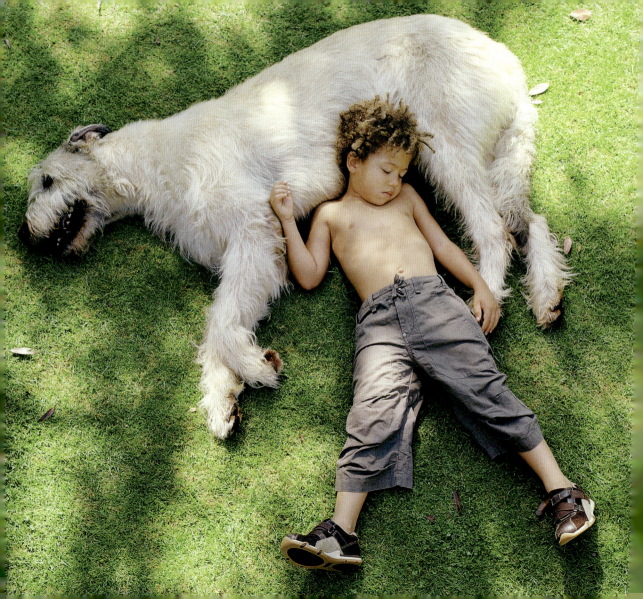

"A well-spent day brings happy sleep."

—Leonardo da Vinci

Make it squeak until someone pays attention.

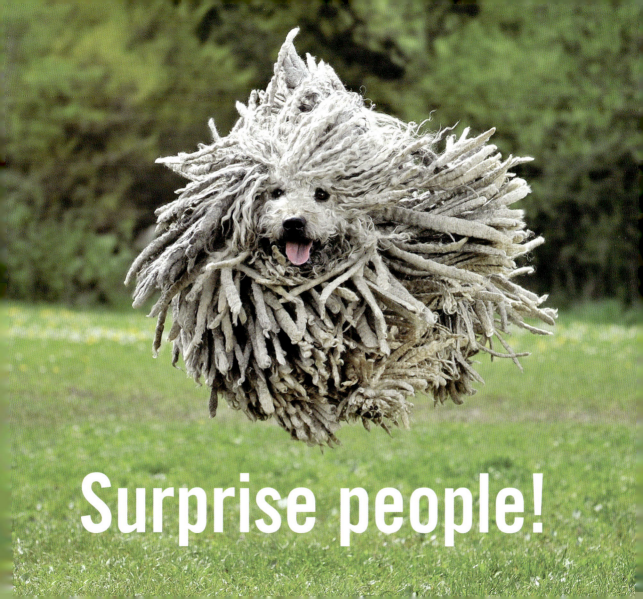

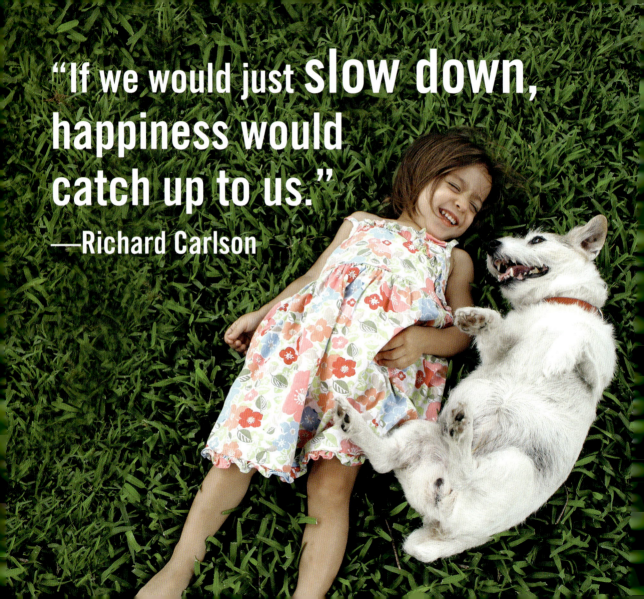

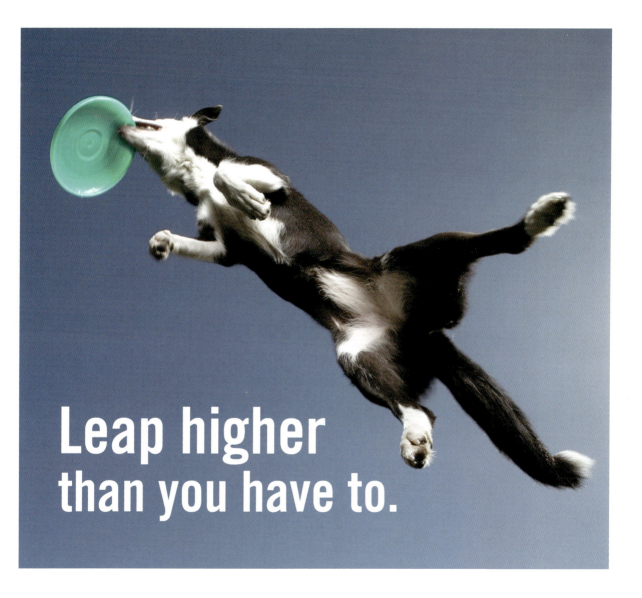

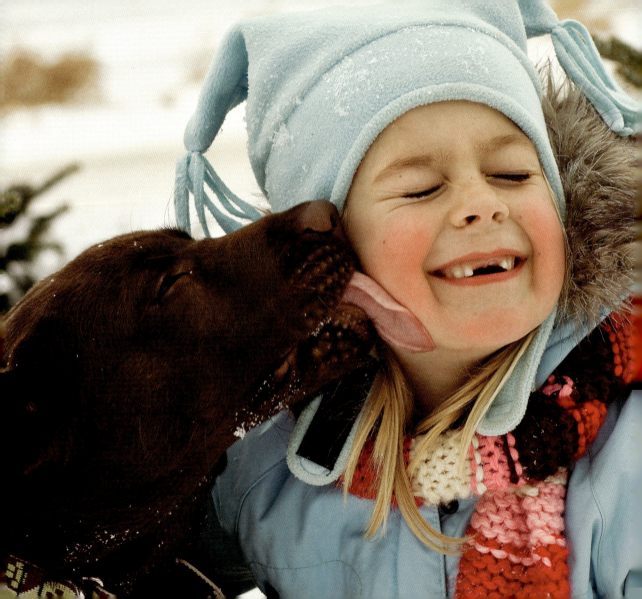

Love is
an action word.

Dogs don't just feel love, they show it consistently and with enthusiasm. They try to lift us up when we are down and they celebrate with us when we rejoice. They treat old friends with kindness and approach new friends with optimism and enthusiasm. Dogs never withhold affection, nor do they suddenly decide we're not worthy of their love. Loyal to the end, they love us unconditionally, with deep and everlasting devotion.

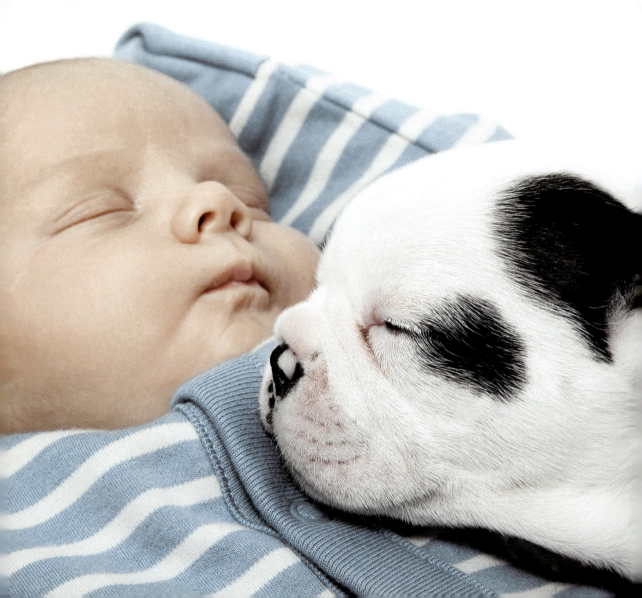

Take care of the littlest ones.

"Dogs have a way of finding the people who need them."
—Thom Jones

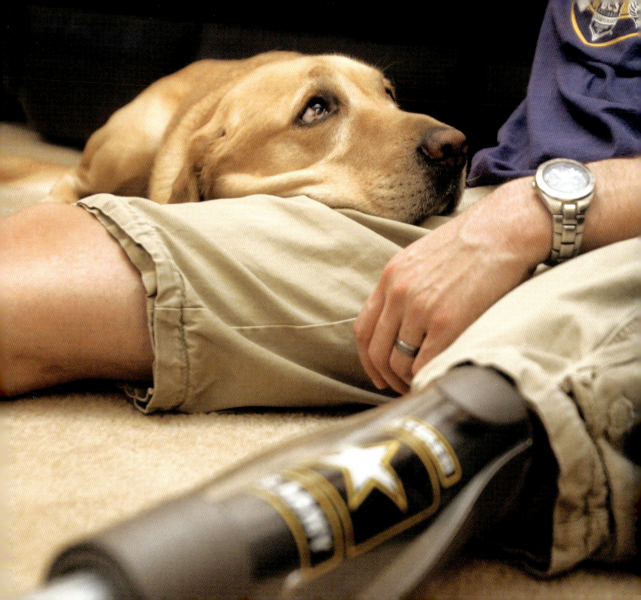

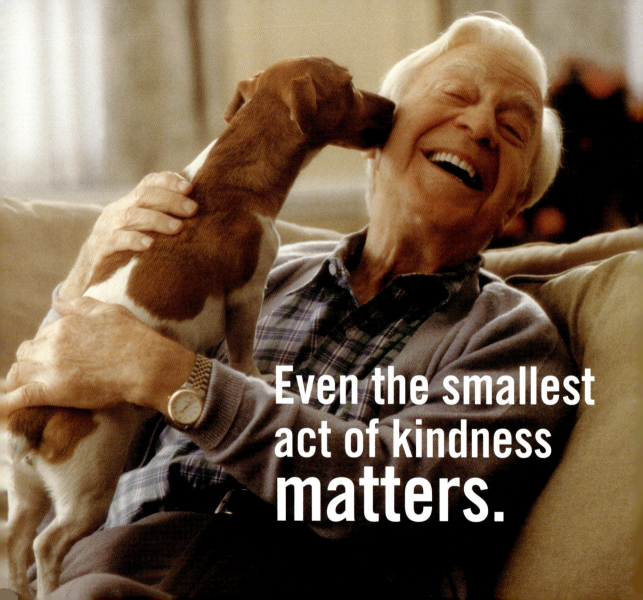

5 things you and your dog can do together to make a difference:

Team up with your dog for therapeutic visits. Lift the spirits of people in nursing homes, hospitals, and detention facilities.

Give blood. Dogs can give blood, too—at special pet blood banks.

Walk for a good cause. Sign up for a charity walk or run that allows dogs to participate.

Foster a shelter animal. Help a prospective pet feel more comfortable around people and other dogs.

Train to be a search-and-rescue team. After a two-year program, you and your dog can help out in a crisis.

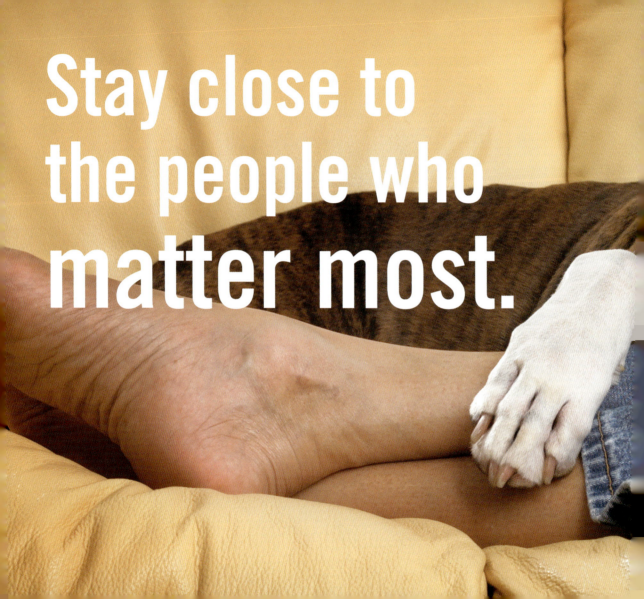

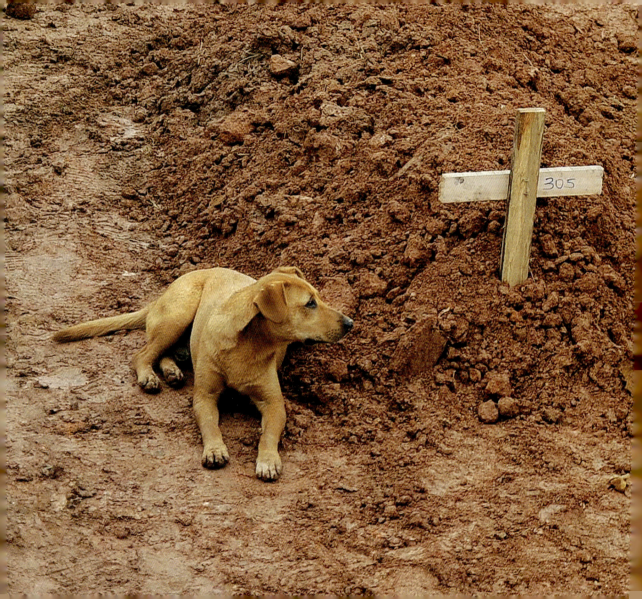

"We give dogs time we can spare, space we can spare, and love we can spare. And in return, dogs give us their all. It's the best deal man has ever made."

—M. Acklam

Leao refused to leave the gravesite of his owner, Cristina Maria Cesario Santana, after the 2011 mudslides that killed her and many others in Brazil.

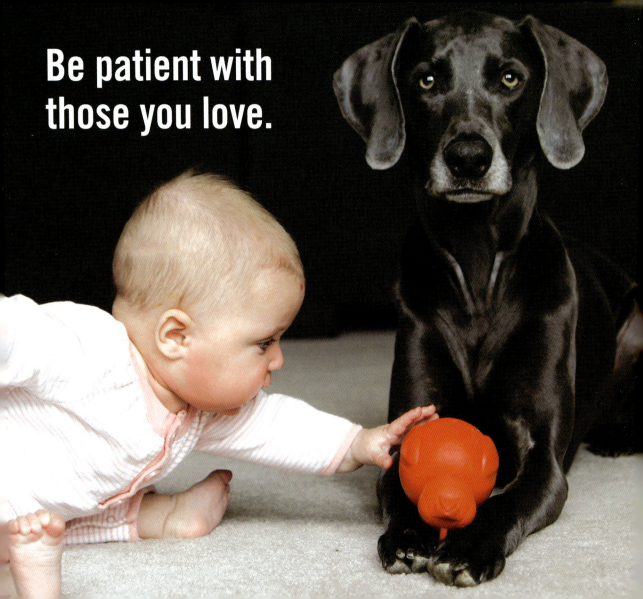

Look for opportunities to be kind.

Blakely, an Australian shepherd rescued at eight months of age, helps raise at-risk baby animals at the Cincinnati Zoo. Whether he's snuggling with an orphaned wallaby or a bat-eared fox, teaching an ocelot kitten to drink milk from a bowl, or wrestling playfully with a growing cheetah, Blakely seems to know instinctively what each animal needs in order to thrive.

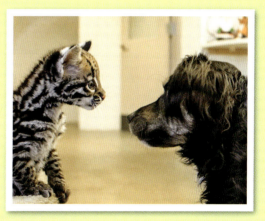

Blakely, canine nanny, attends to one of his charges.

"Approach each new person you meet in a spirit of adventure."
—Eleanor Roosevelt

Dogs provide more than just companionship; they actually serve as social catalysts, motivating us to get out more and helping us approach other people more easily. In fact, people who walk dogs have three times as many social interactions as folks without dogs!

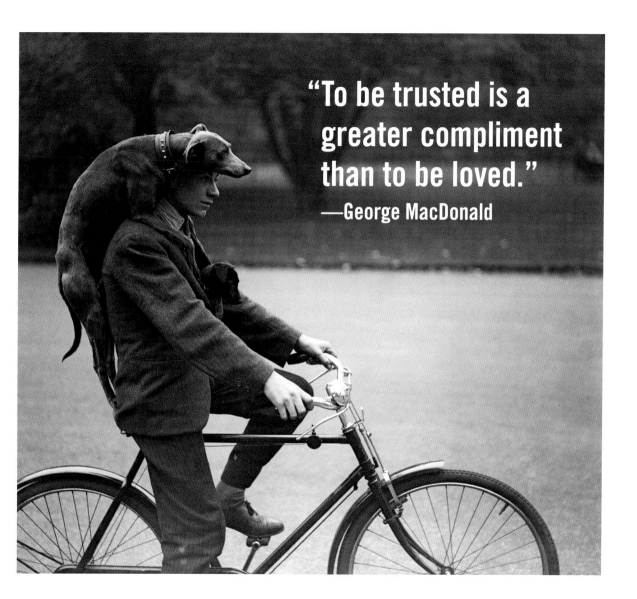

"Nations will rise and fall. Wars will be lost and won. Lives will begin and end, but a true friend is eternal."
—Jon Koroluk

As the funeral of fallen Navy SEAL Jon Tumilson began, his grieving Labrador retriever, Hawkeye, walked up to the casket and lay down beside it with a sigh. Tumilson was among 30 Americans killed when Taliban insurgents brought down their helicopter.

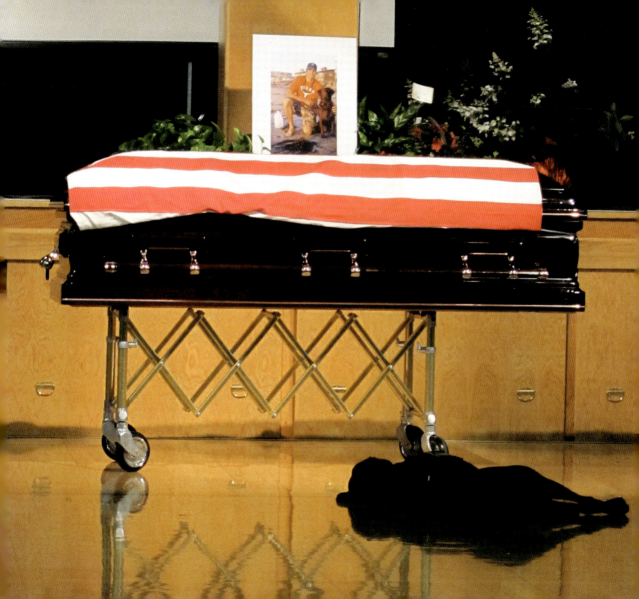

Every day, remind those you love how you feel about them.

Being kissed by your pooch or looking into his eyes can actually change your biochemistry. In studies, people who held the gaze of their loving dogs or who received extended dog kisses showed increases in a range of hormones such as oxytocin, the so-called feel-good hormone. Even more amazing, the dogs in the study showed similar increases in the same hormones! Clearly, the benefits of bonding are mutual.

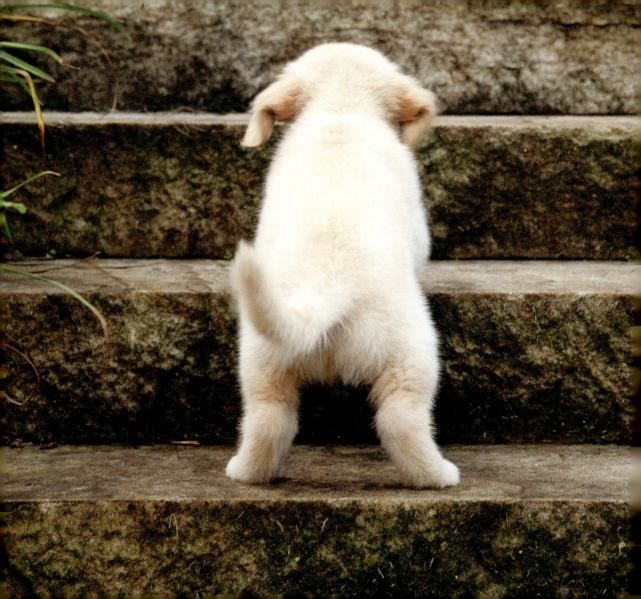

It's the challenges that make life interesting.

With a combination of patience and perseverance, dogs turn obstacles into opportunities and show us what can be accomplished by simply sticking with it. They pursue every goal—whether catching a ball or protecting a loved one—with spirit and determination. Nothing can discourage them or dampen their enthusiasm!

Refuse to be ignored.

When police responded to a call about a barking dog blocking a neighbor's driveway, they followed a frantic border collie mix named Snickers to his house, where they discovered Gregory Gould unconscious. The police determined that Snickers had thrown himself against a back door until he broke through the glass, then had fought through a backyard fence. He barked and paced for two hours until 5 a.m., when neighbors finally called 911. Without the efforts of Snickers—adopted just a month earlier—Gregory would not have survived.

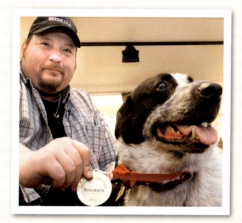

Snickers was inducted into the Purina Animal Hall of Fame for showing courage, determination, and fearless devotion.

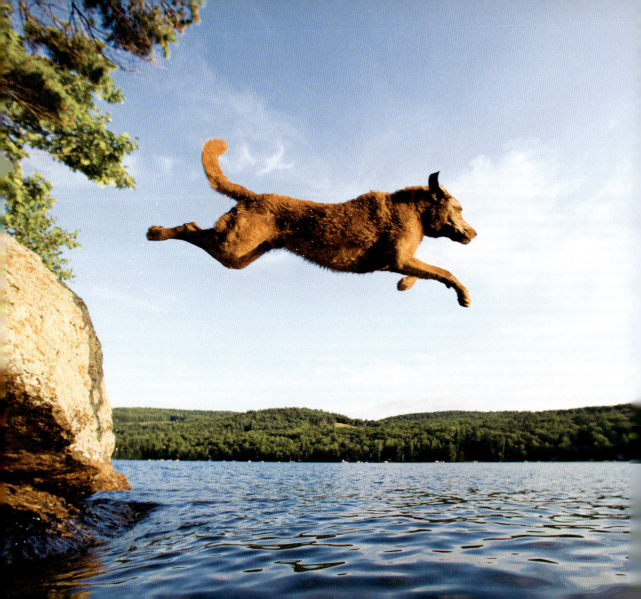

"**If your ship doesn't come in, swim out to meet it!**"
—Jonathan Winters

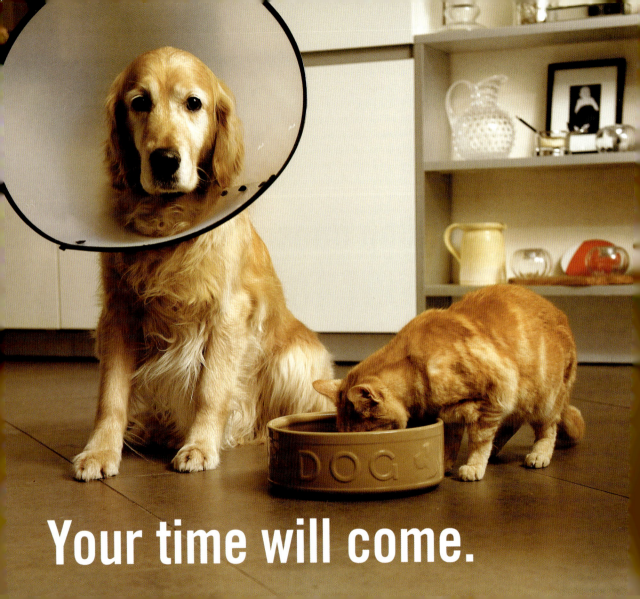

"It's not the size of the dog in the fight, it's the size of the fight in the dog."
—Mark Twain

The best things are **worth the wait.**

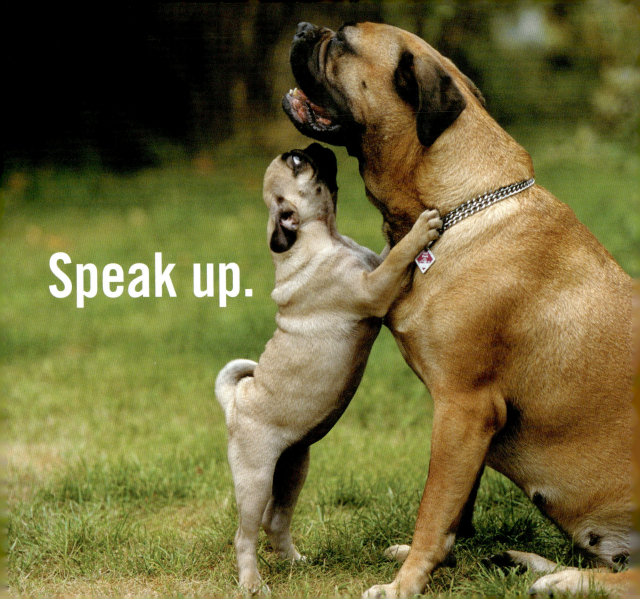

Keep going
until you find your way home.

When Mason, a terrier mix, was swept up by one of the devastating tornadoes that hit Alabama in 2011, his heartbroken family feared he was gone forever. But three weeks later, when they returned to the site of their home to sift through debris, they found the remarkable pup waiting for them on what was left of their porch. Despite two broken legs, he had managed to crawl through the wreckage to return home.

Mason rests in his yard with both front legs in casts.

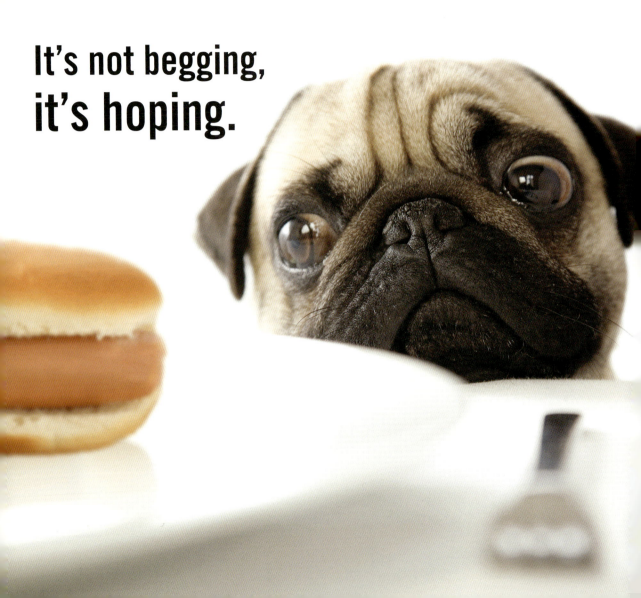

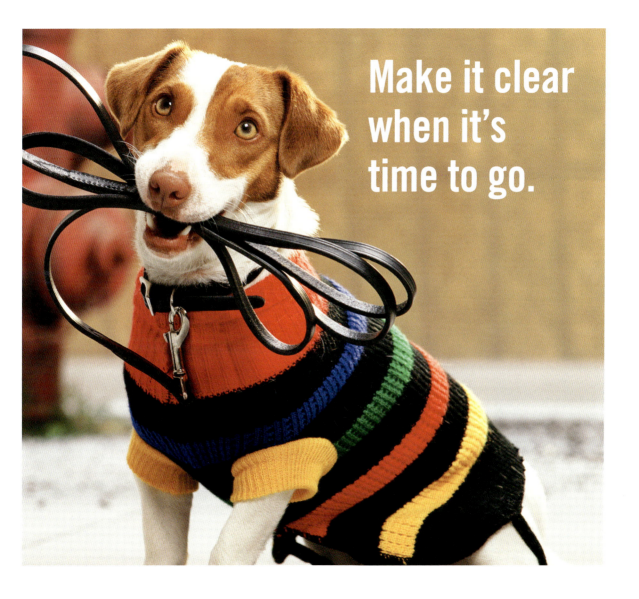

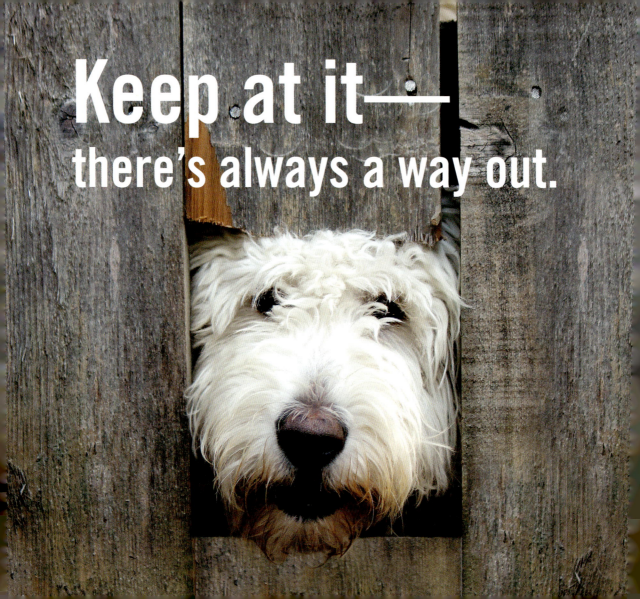

"If you don't go after what you want, you'll never have it. If you don't ask, the answer is always no. If you don't step forward, you're always in the same place."
—Nora Roberts

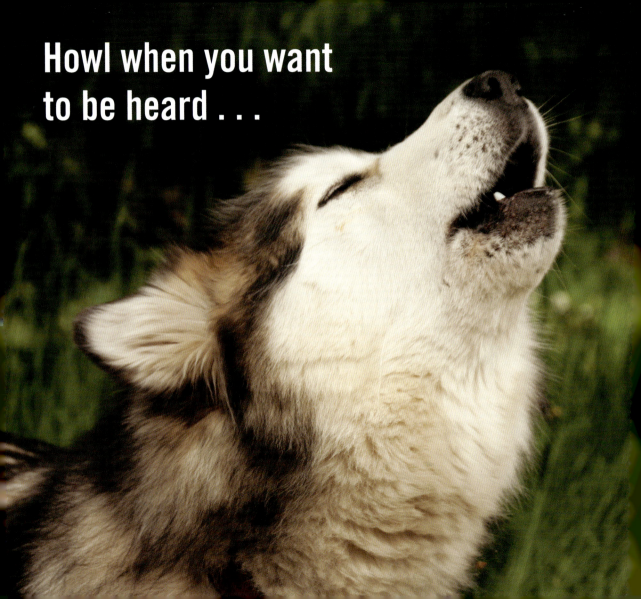

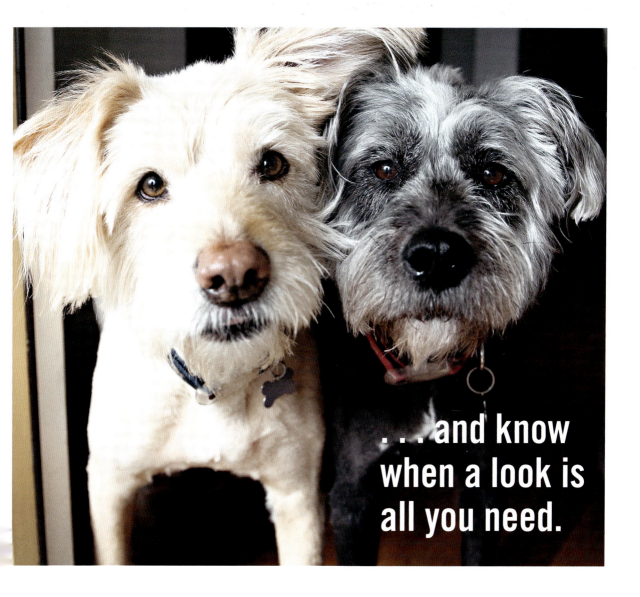

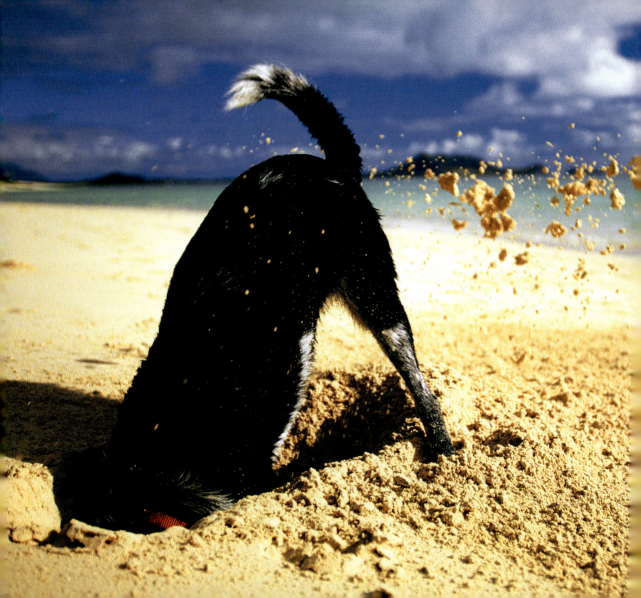

Keep digging until you find **what you're looking for.**

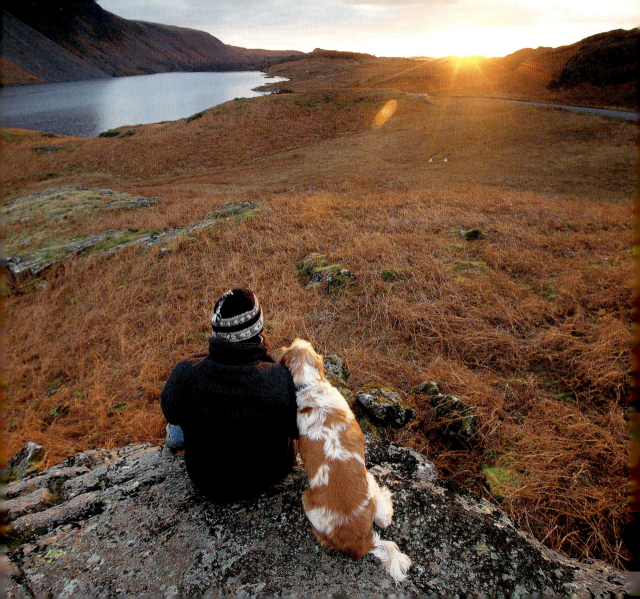

Strive for just enough.

The secret to a happy life is balance. Nothing in excess but enough of everything: enough food, rest, work, play, affection. Dogs value quiet moments of replenishment as much as moments of accomplishment. For them, an afternoon spent lying outside in the warm sun with a friend is just as valuable and meaningful as time spent embarking on an adventure.

It's about knowing when to run and when to rest.

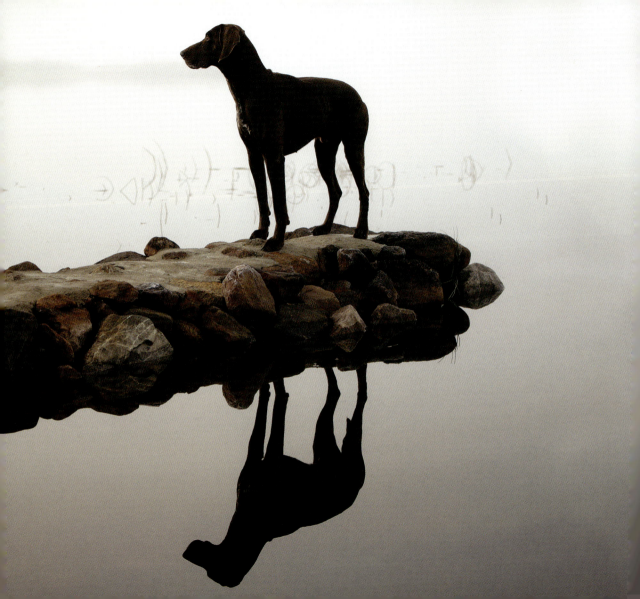

Pause, ponder.

"Empty your mind of all thoughts.
Let your heart be at peace."
—Lao-tzu

Nap. Play. Eat. Repeat.

> "If speaking is silver, then listening is gold."
> —Turkish proverb

Serenity is not the absence of clamor and commotion, but the ability to find peace in the midst of it.

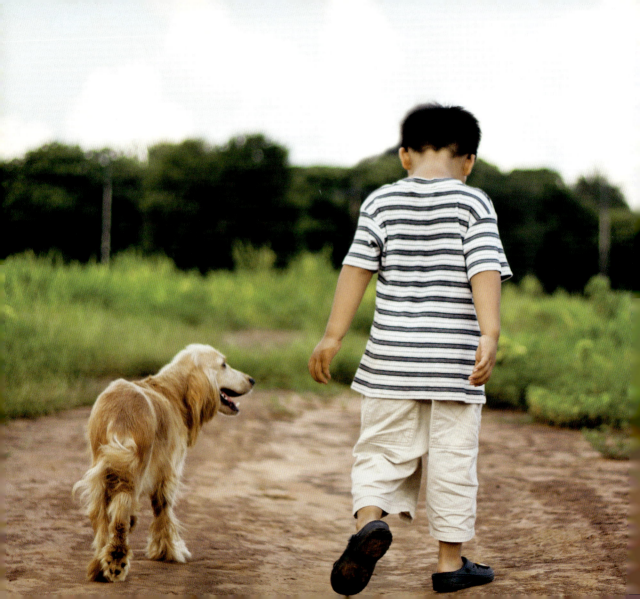

Never turn down an opportunity to go for a walk.

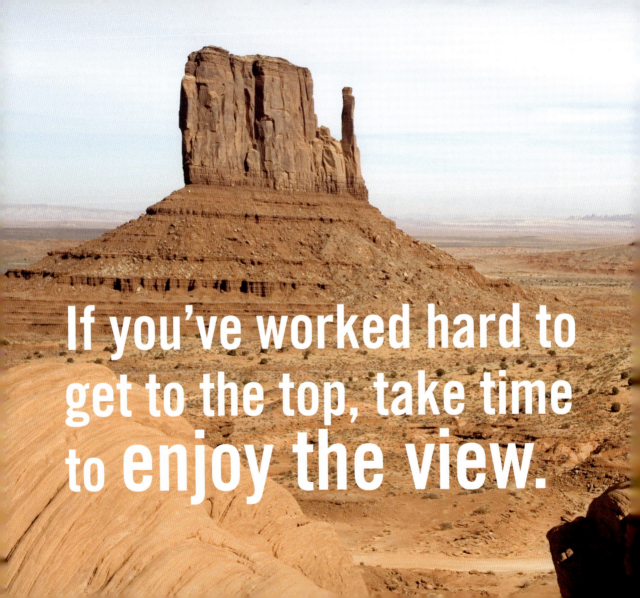

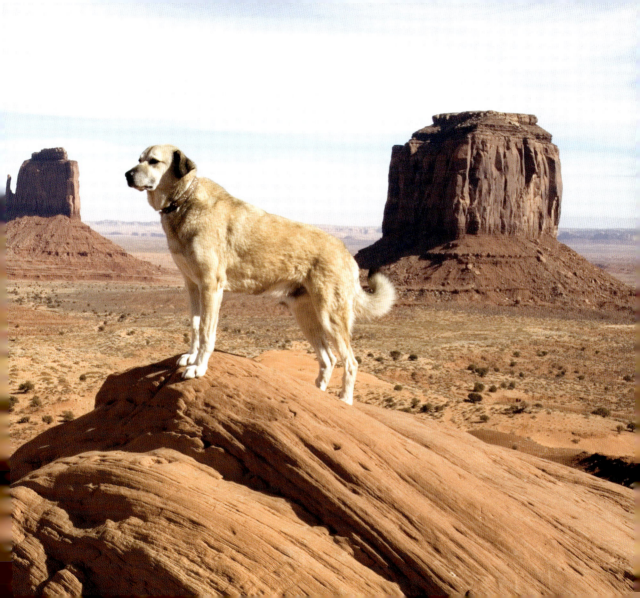

To be more productive, do a little less.

Taking time off seems counterintuitive to getting more done, but our personal resources are not infinite and we must let ourselves recharge to avoid burnout and be at our best. The more that is asked of us, the greater the need for renewal.

Be your own champion.

Chihuahuas don't waste time wishing they were Rottweilers. A mutt is as confident as a purebred. No dog suffers from feelings of inadequacy or issues of self-esteem; no dog compares himself to other dogs to determine his self-worth.

Your pup feels valued and worthy just the way he is, deserving of your love, attention, and praise. His self-acceptance is genuine. He's not Lassie or Rin Tin Tin, and he's okay with that. He loves himself almost as much as he loves you.

Insist on being treated fairly.

Don't wait to be asked to play.

You don't have to roll over and play dead *every* time you're asked.

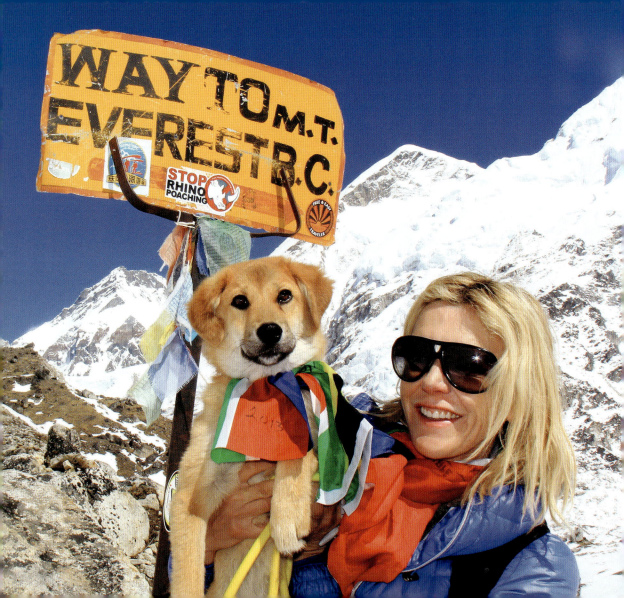

"It ain't what they call you, it's what you answer to."
—W. C. Fields

Rupee, rescued from a dump in India, is the first dog officially recorded at the Mt. Everest base camp. Near death when Joanne Lefson found him, Rupee made a remarkable recovery and was able to complete the demanding climb with his new owner in just ten days. Because he'd been born in the Himalayas, Rupee did not suffer from altitude sickness, even at more than 17,000 feet. And now Rupee's on top of the world—in more ways than one.

Don't allow an unfortunate backstory to dictate your future.

Popsicle, once used in dog fighting, was starving and near death when he was found in a freezer on a drug dealer's porch. But his story didn't end with that sad chapter. The pit bull took part in a drug-dog training program and proved to be the smartest in his class, graduating first!

Popsicle sniffed out drugs hidden in a pineapple truck.

"From humble beginnings come great things."

—Proverb

If you love mutts, mark your calendar for National Mutt Day, December 2.

Claim your rightful spot.

Don't let anyone tell you you're not a lapdog.

"Your time is limited, so don't waste it living someone else's life. . . . Have the courage to follow your heart and intuition."
—Steve Jobs

Appreciate
life's simple pleasures.

In return for a pat on the head or a quick belly rub, dogs reward us with boundless appreciation. Thankfulness is a habit for them, and gratitude is a way of life. Leftovers are greeted with as much enthusiasm as a gourmet meal. A trip to the dump is as thrilling as a trip to the Grand Canyon. Because they are not burdened by what could be, dogs are fully able to enjoy what is.

Every meal is THE BEST MEAL EVER.

APPRECIATE LIFE'S SIMPLE PLEASURES

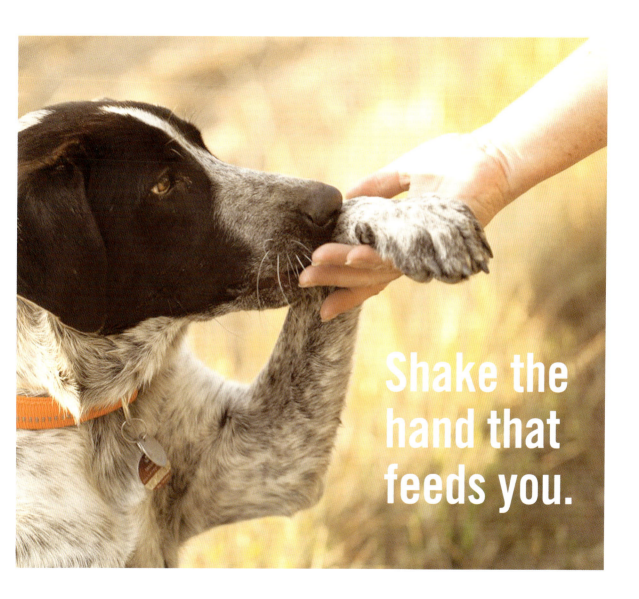

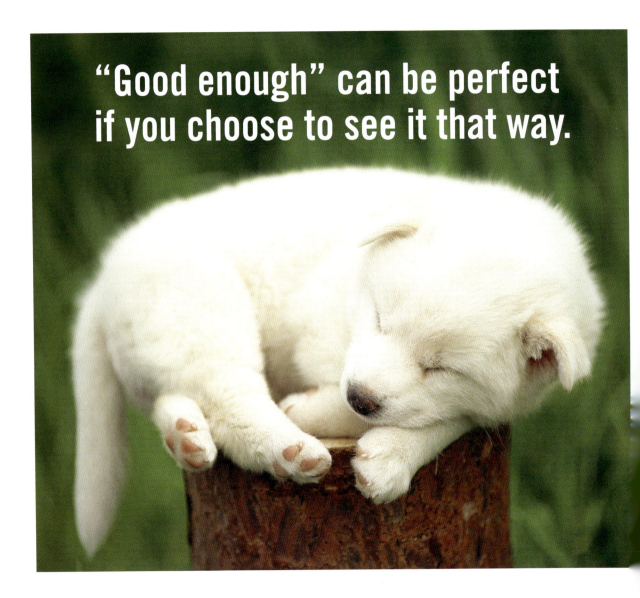

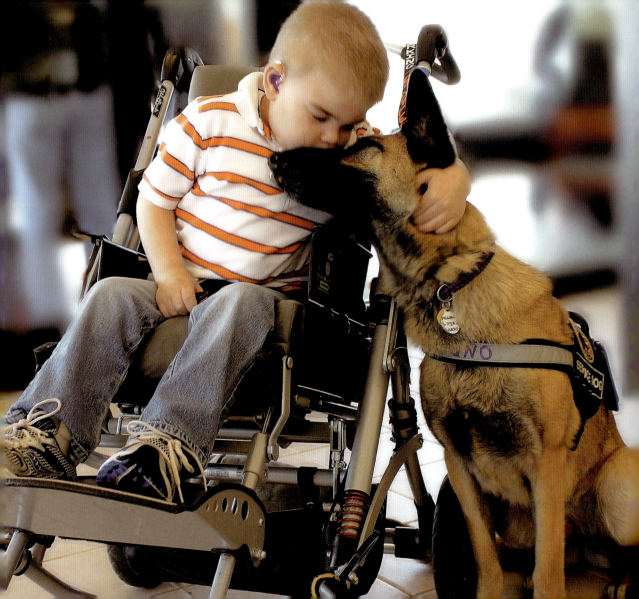

> "When we give cheerfully and accept gratefully, **everyone is blessed.**"
> —Maya Angelou

When Lucas Hembree's father, Chester, was told that his dying son was not a good candidate for a trained service dog, he refused to give up on the idea. Instead, he adopted Juno, a Belgian Malinois just days from being euthanized, and planned to train her himself. From the start, Juno instinctively seemed to understand that it was her job to care for and comfort Lucas, and several times alerted Chester when Lucas's oxygen levels were too low—even before her training began! Lucas saved Juno's life, and now she is returning the favor.

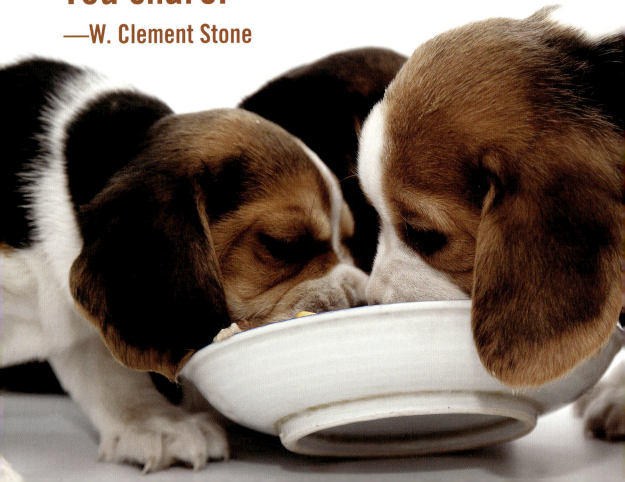

"If you are really thankful, what do you do?
You share."
—W. Clement Stone

Inspire others.

Because he hasn't allowed his own disability to impact his zest for life, Arlo the dachshund provides hope to the patients he visits at a Dallas rehabilitation clinic. Found dragging himself along the side of the road, the pup with the degenerative disc disease would have been euthanized if he hadn't been adopted by Bettye and Jim Baker. The couple signed Arlo up to participate in the Baylor Animal Assisted Therapy program when they realized that their special dog could offer a unique kind of encouragement to patients.

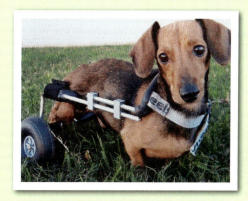

Arlo inspires human patients at the Baylor Institute for Rehabilitation.

It's about the legs you DO have.

"Be content with what you have, rejoice in the way things are. When you realize there is nothing lacking, the whole world belongs to you."
—Lao-tzu

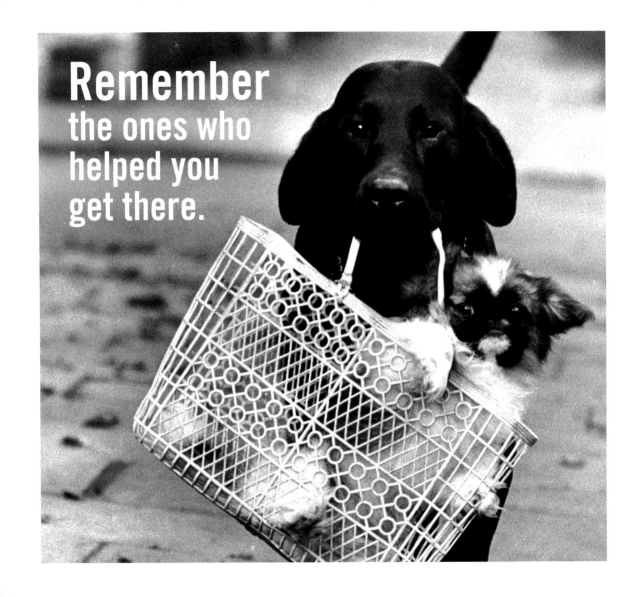

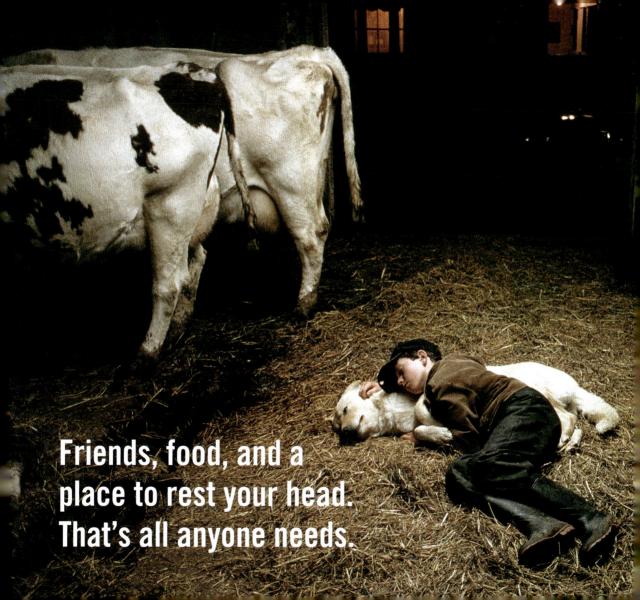

Celebrate ordinary moments.

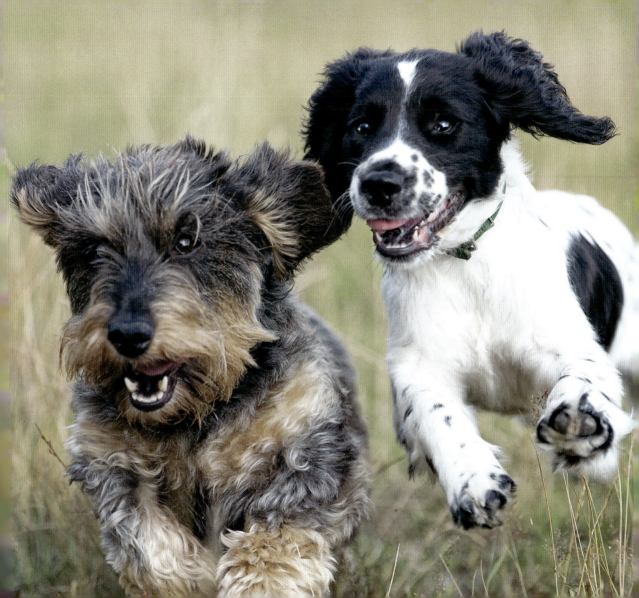

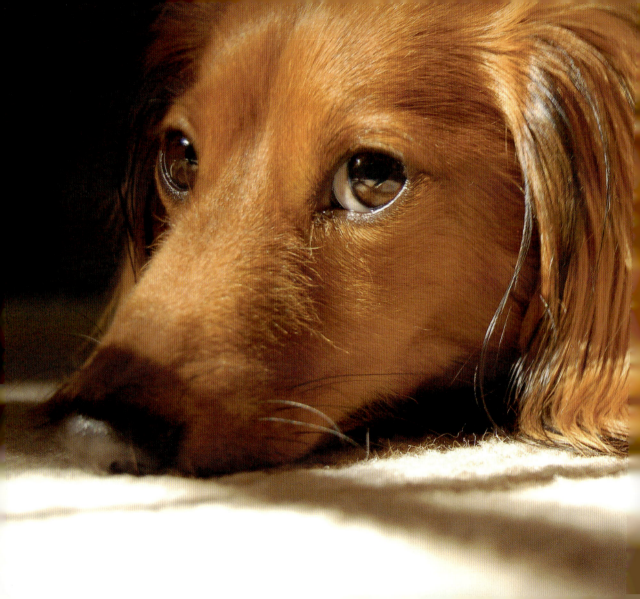

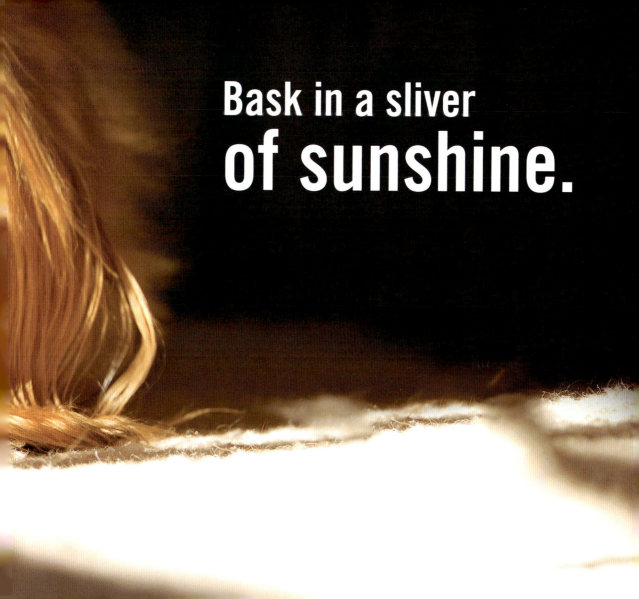

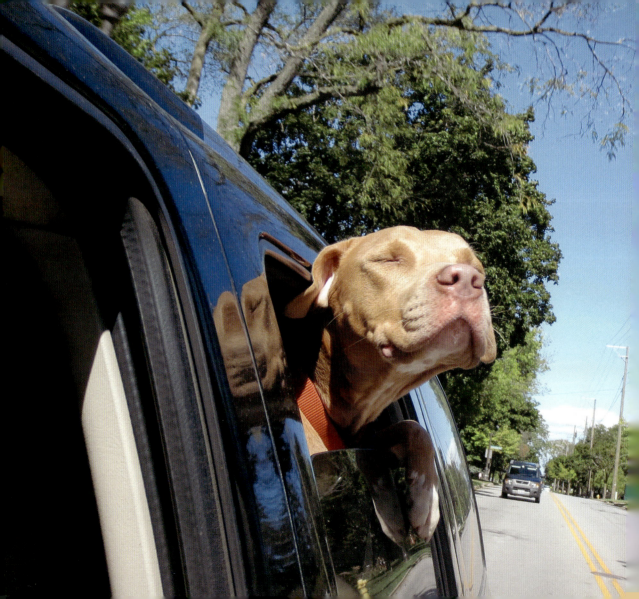

Just enjoy the ride.

After a lengthy wait at Chicago Animal Care and Control, this pup was finally adopted; the photo was taken on the way to his permanent home.

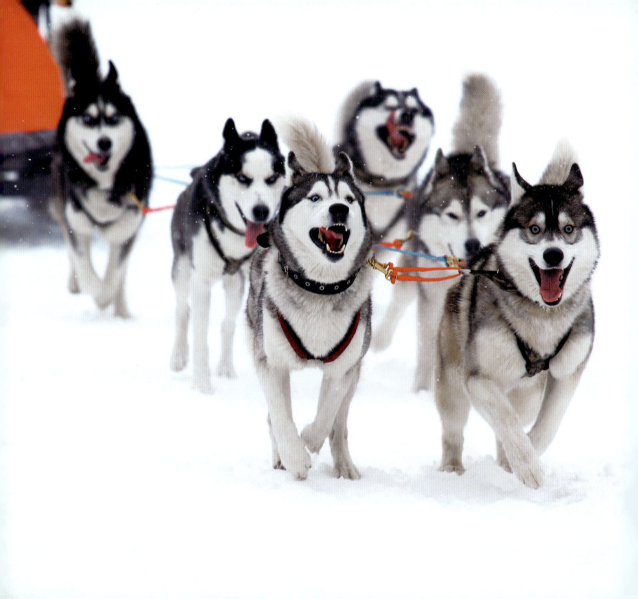

Contribute to
the pack.

A dog craves purpose. He wants to expend energy, solve problems, engage with others, and embark on interesting adventures. He is eager to comfort or protect, to herd or to hunt. No matter what a dog's size or temperament, he is waiting and watching for a chance to make a contribution.

A dog's purpose is his passion.

Come when you are called.

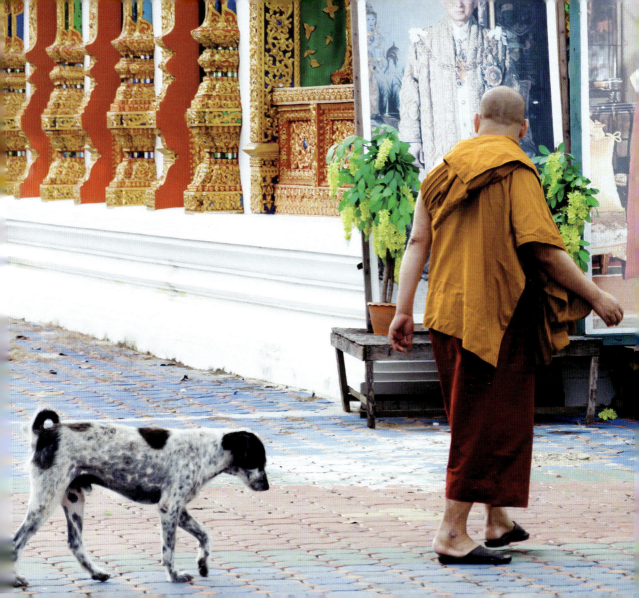

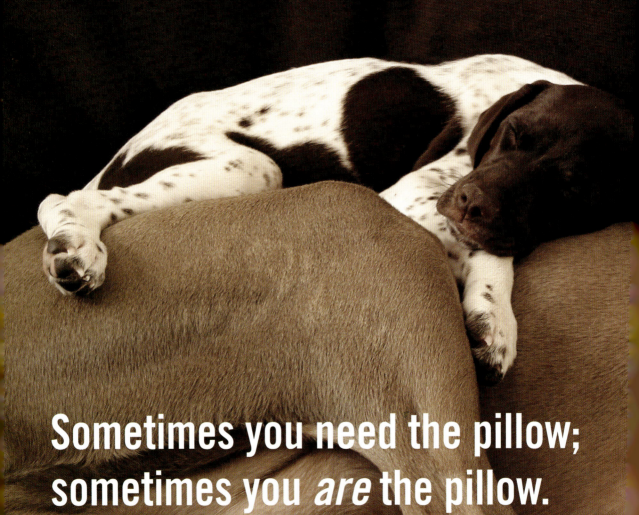

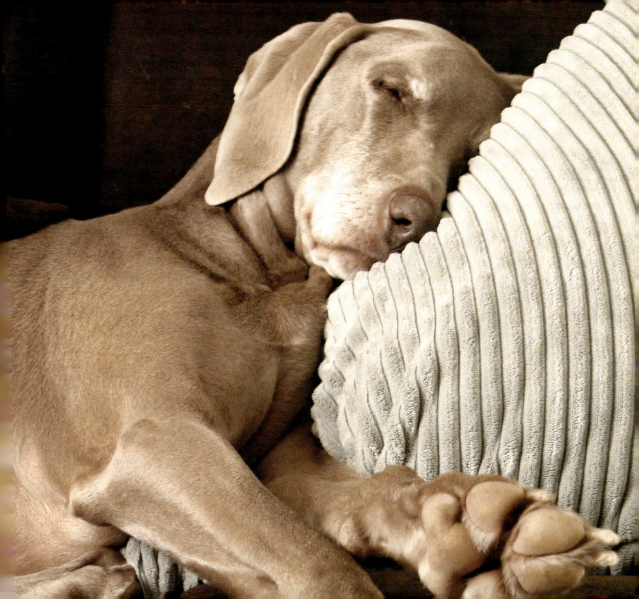

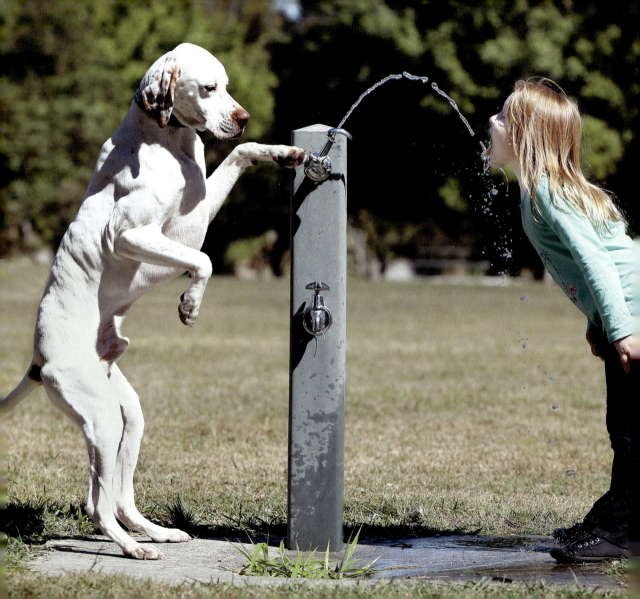

Work together.

CONTRIBUTE TO THE PACK

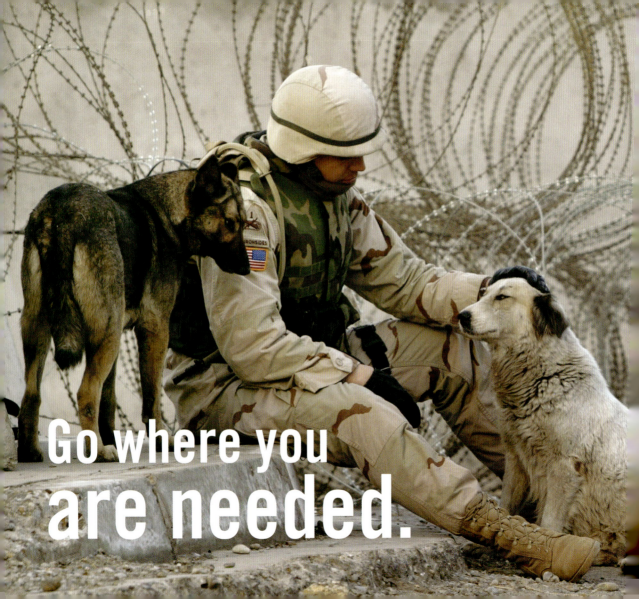

"It's never too late to be what you might have been."
—attributed to George Eliot

Once a fighting dog for infamous quarterback Michael Vick, Daisy Mae is now a therapy dog in Santa Barbara, California. Gentle and loving, she comforts children who've been hospitalized and cuddles with the elderly in retirement homes.

Most of the dogs rescued from Vick's fight farm were rehabilitated and placed in loving homes.

Daisy Mae snuggles with a resident of a retirement home.

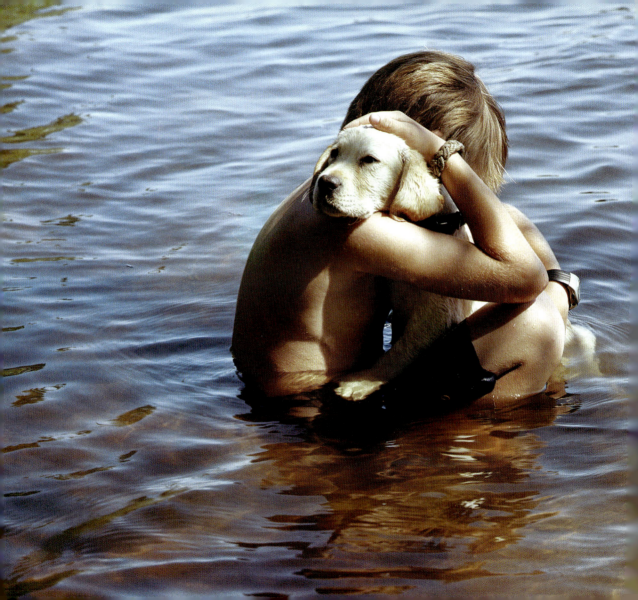

"I have found that when you are deeply troubled, there are things you get from the silent devoted companionship of a dog that you can get from no other source."
—Doris Day

Don't feel as if you have to change the world. Just try to make your corner of it a little better.

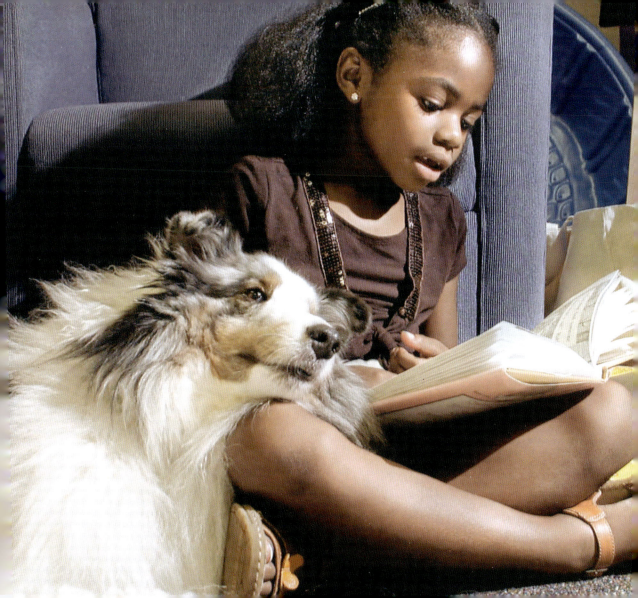

Be a hero.

Omar Eduardo Rivera, a blind computer technician, was working on the 71st floor of the World Trade Center's north tower on September 11, 2001, when a hijacked plane flew into the skyscraper. After Omar and his guide dog, Salty, fought their way to the stairwell, he unclipped the dog's leash and ordered him to go. Convinced he would die, Omar wanted to give his beloved Labrador retriever a chance to survive. But Salty refused to leave his owner's side, despite the panic and the intense heat. For nearly an hour, Salty patiently guided Omar down 70 flights of stairs to safety. The tower collapsed shortly after they escaped.

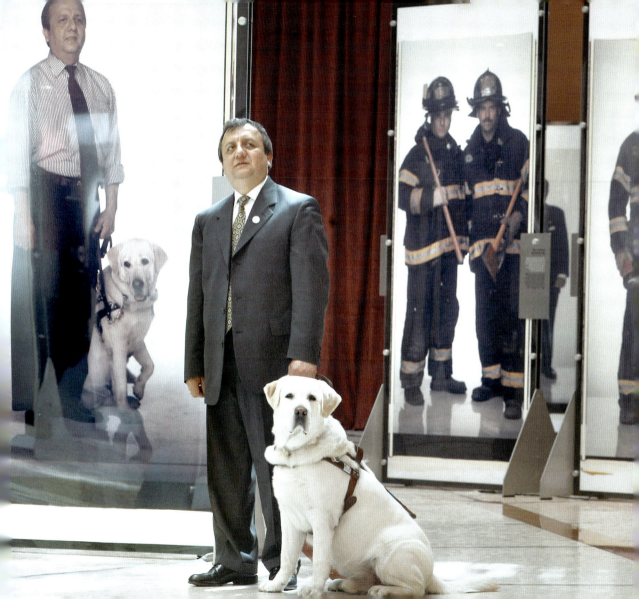

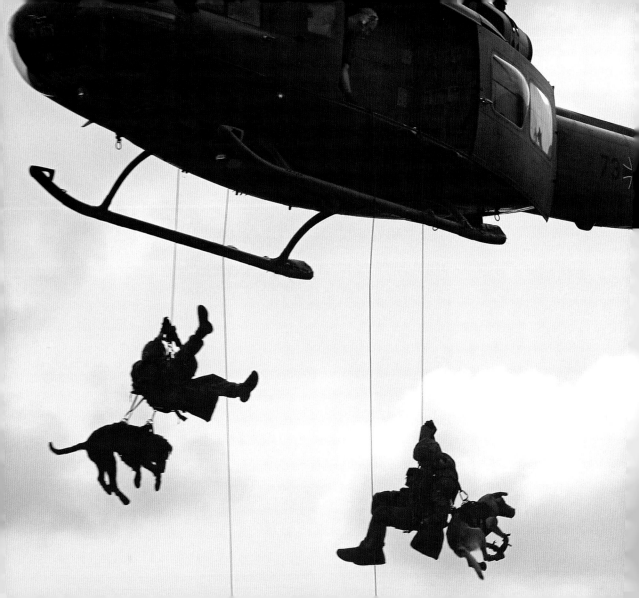

Act nobly, even if no one will remember your name.

Little is known about what may be the bravest dog in the country. The Navy SEALs who stormed the compound of Osama bin Laden were accompanied by a trained, body-armored, explosives-sniffing dog who'd been lowered from a Black Hawk helicopter. The military will not reveal the breed involved in bringing down bin Laden, but the most common breeds used in war are German shepherds and Belgian Malinois. Both breeds have strength, speed, intelligence, courage, and a keen sense of smell.

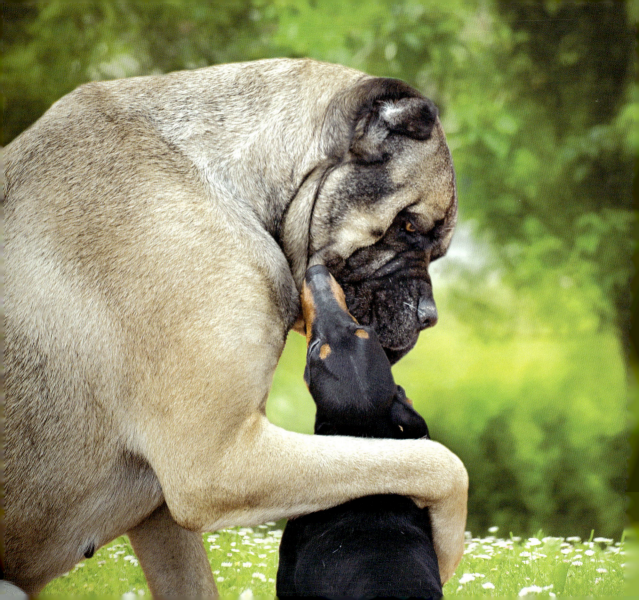

Let it go.

Dogs choose to forgive for the good of the pack. They don't take things personally and never hold grudges. With their canine and human friends alike, they resolve conflicts quickly and move on, letting go of negative feelings to focus on happier, more important things. (And when they are the ones who need forgiveness, they'd like us to follow their lead.)

There are **no** "bad dogs," just lessons to be learned.

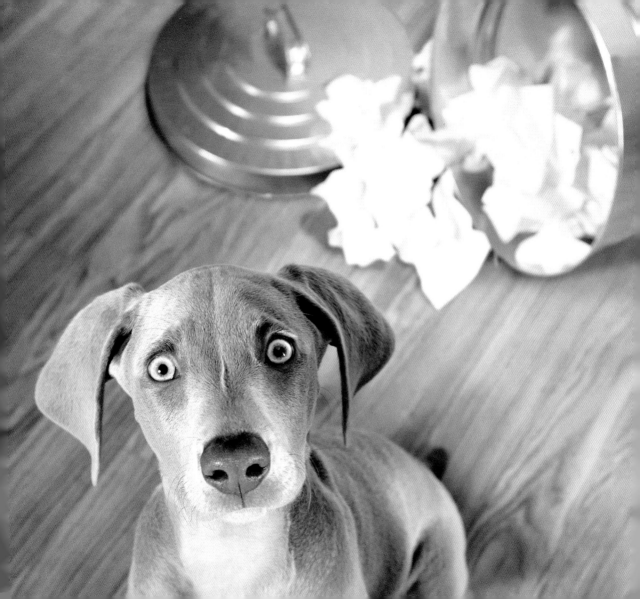

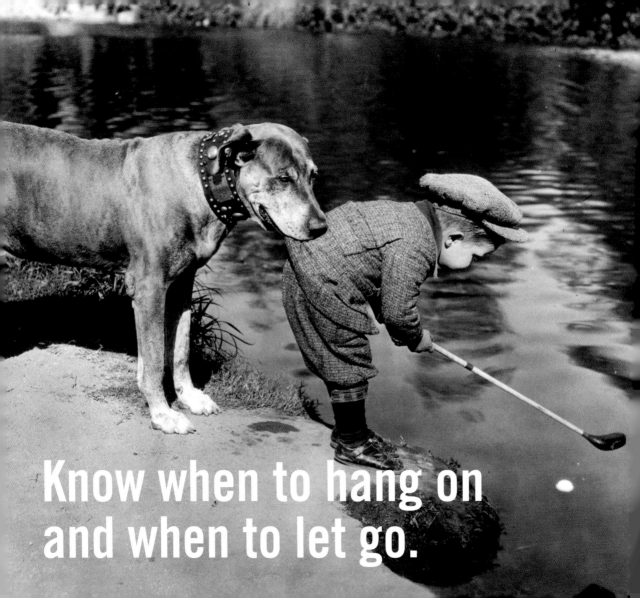

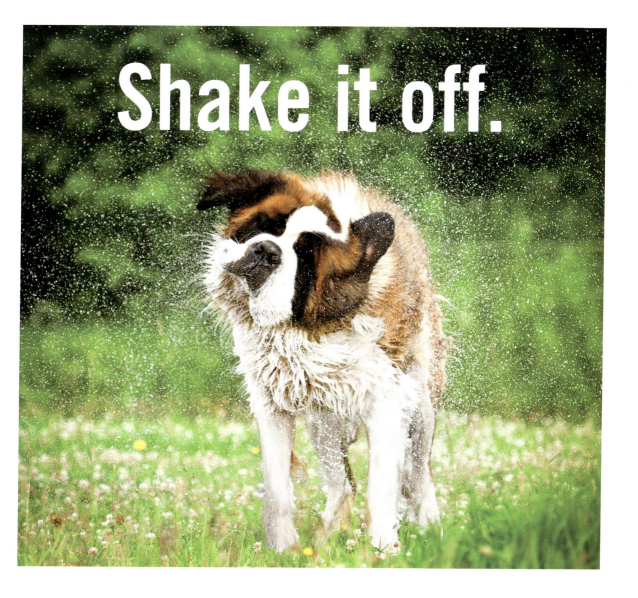

You *can* roll around in a pile of dead fish, but you have to accept the consequences.

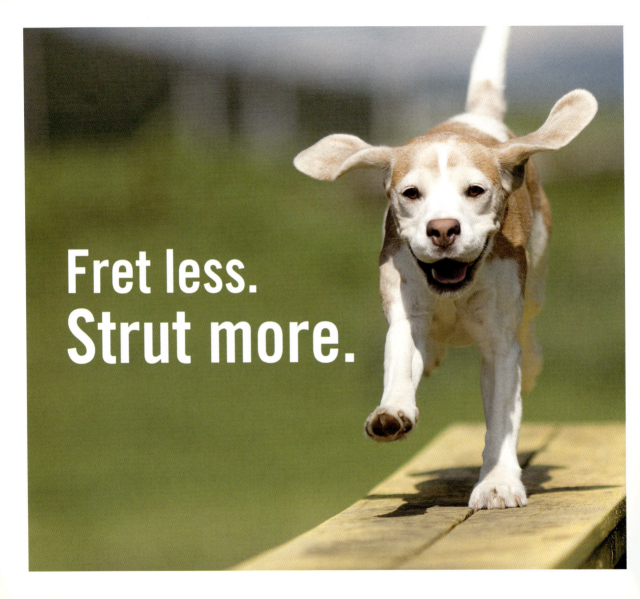

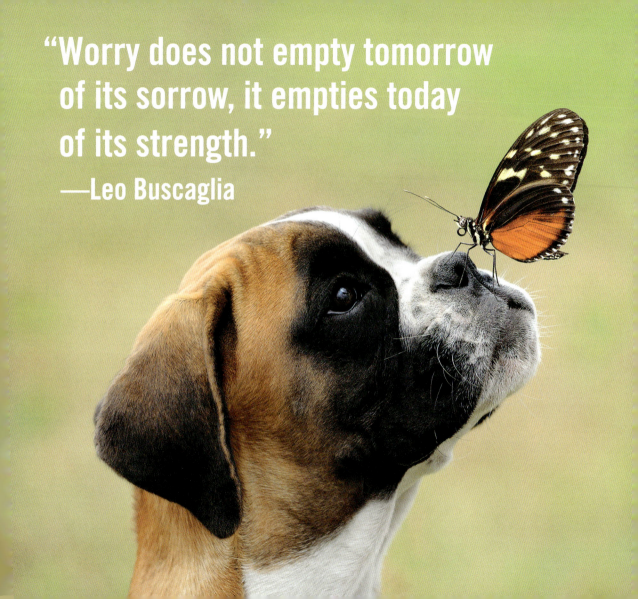

Every day is the best day.

A dog's life is blessedly uncluttered. He has no regrets over what happened yesterday, and he doesn't fret about tomorrow. He lives in the present, eager and optimistic.

His world is not as frantic as ours; he lingers on an interesting scent and stops to greet a new friend. He is clear about what he wants: to go out, to come in, to have lunch, to play tug-of-war. There are no ulterior motives, no hidden agendas. Fetch is just about fetch. He doesn't tally favors or withhold affection.

Car trip? Yes! Guilt trip? Not a chance.

Nothing else matters right now but the belly rub.

"We have only this moment, sparkling like a star in our hand, and melting like a snowflake."

—Marie Beynon Ray

Take it one hurdle at a time.

In the sport of dog agility, handlers guide their dogs through an obstacle course, racing for time as well as accuracy. You can set up an agility course in your backyard that mimics the one used in actual trials:

Weave poles: Poke a dozen driveway markers into the ground, spaced about two feet apart, for your dog to weave around.

Standard jumps: Suspend a plank between two cinder blocks (add blocks to increase height) for your dog to jump over.

Dog walk: Use a picnic bench for your dog to walk across.

Tunnel: Anchor a collapsible children's play tunnel to the ground for your dog to maneuver through.

Tire jump: Hang an old bike tire from a sturdy tree branch at an appropriate height so your dog can jump through it.

Teeter board: Center a long plank (covered with a carpet scrap) on a large piece of PVC pipe and anchor it so that it acts as a seesaw; your dog can walk up one side and down the other.

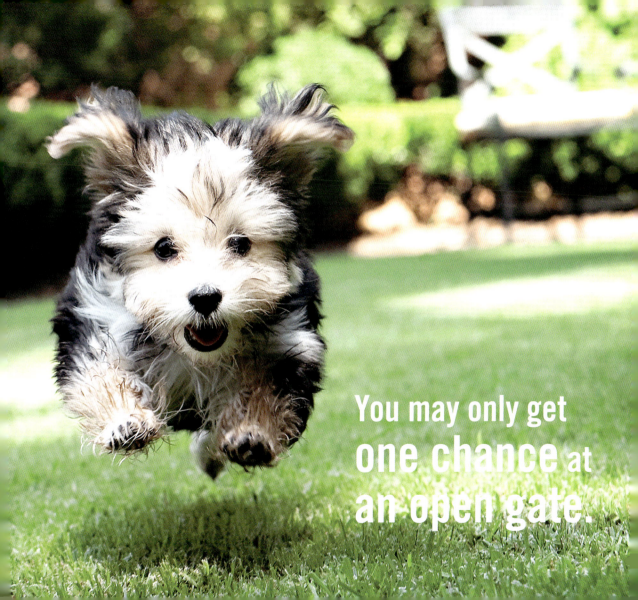

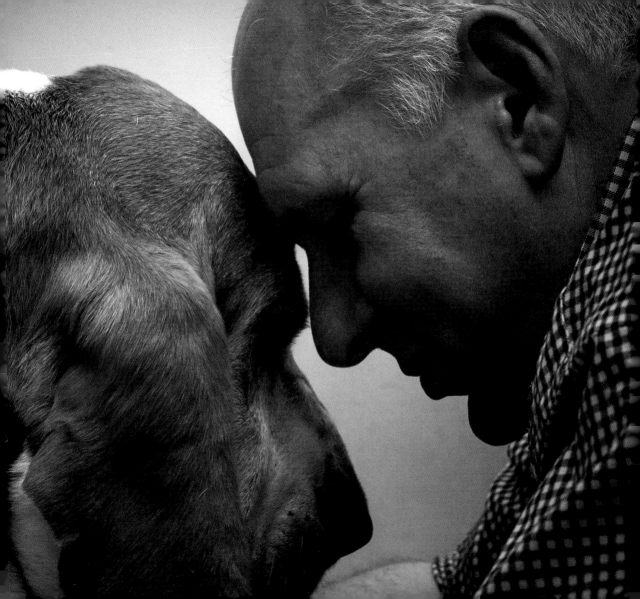

Age gracefully.

Age neither defines a dog, nor overwhelms his thoughts. Because they live in the present, dogs don't see time the way we do, regretting years gone by and obsessing over the days that are left. An old dog doesn't focus on what he can no longer do, but what he still can do. Dogs cope, they adapt, they look for reasons to wag their tails. And no matter what, they never do the math and figure out how old they are in dog years.

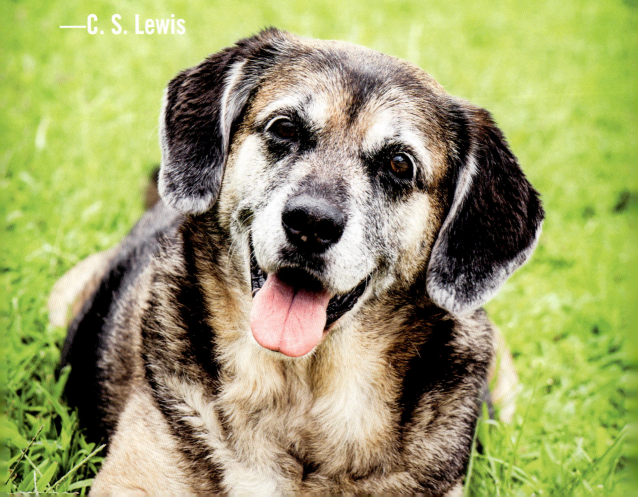

"You are never too old to set another goal or to **dream a new dream.**"
—C. S. Lewis

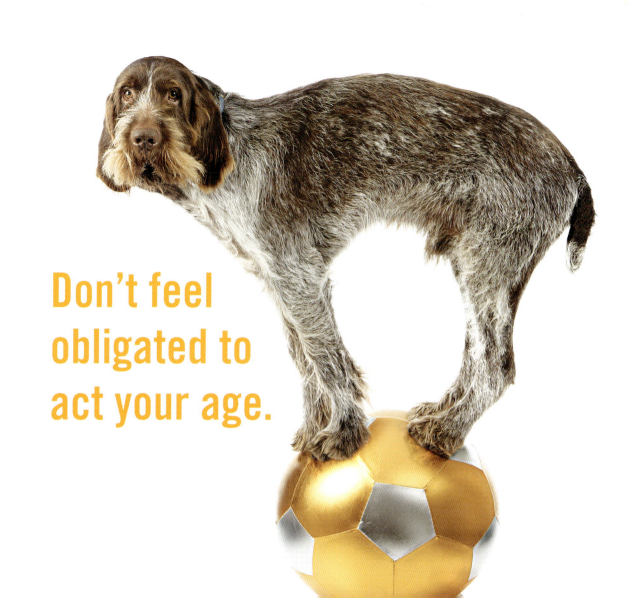

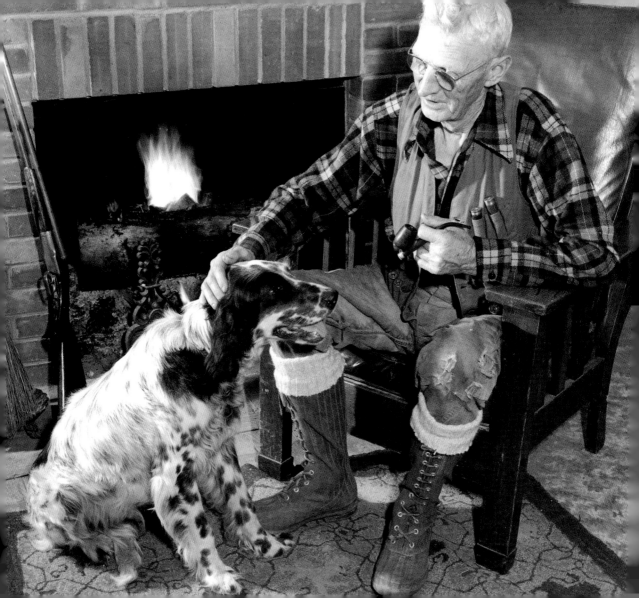

"I can't think of anything that brings me closer to tears than when my old dog—completely exhausted after a hard day in the field—limps away from her nice spot in front of the fire and comes over to where I'm sitting and puts her head in my lap, a paw over my knee, and closes her eyes, and goes back to sleep. I don't know what I've done to deserve that kind of friend."
—Gene Hill

Your body may be tired, but you can **chase squirrels and leap fences** in your dreams.

Be true to the end.

Every afternoon at four o'clock, Professor Hidesaburō Ueno returned from work to find his faithful Akita, Hachikō, waiting for him at Tokyo's Shibuya Station. One day in May 1925, Ueno didn't get off the train; he had died of a stroke while at the university. But Hachikō returned to the station at four the next day—and every day after that for ten years—searching for his owner among the passengers who disembarked the train. The stationmaster eventually made him a bed and left food and water for him. A year before Hachikō died, a statue of him was installed at the station to commemorate his loyalty.

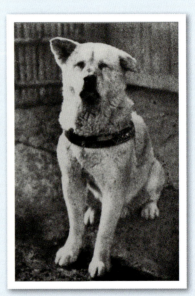

After more than 80 years, Hachikō remains a symbol of loyalty in Japan.

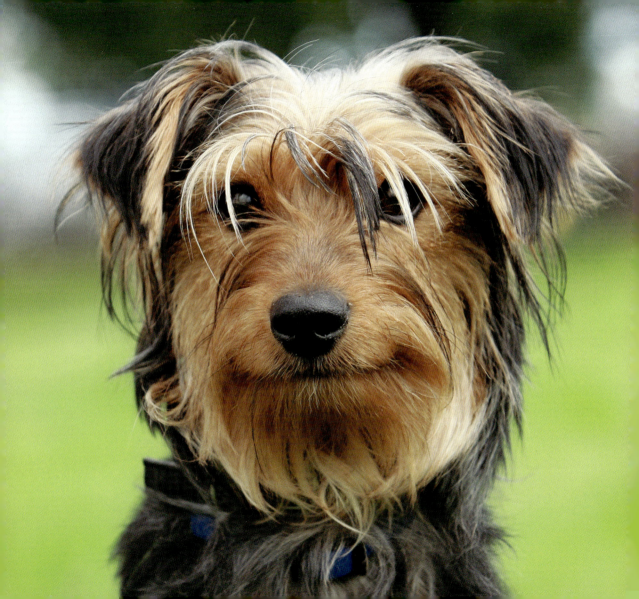

"Don't cry because it's over. Smile because it happened."

—Dr. Seuss

PHOTOGRAPHY CREDITS

Title page: © Warren Photographic; **Table of Contents:** Martin Barraud/Getty Images

age fotostock: Heinz Endler pp. 76-77; Peter M. Fisher p. 102; Johner Images p. 66; Juniors Bildarchiv p. 19; R. Koenig p. 54; Adam Lawrence p. 4; Jose Luis Pelaez p. 28. **Alamy:** blickwinkel p. 94; Larry Goodman p. 123; H. Mark Weidman Photography p. 44; Trinity Mirror/Mirrorpix p. 112. **Animal Photography:** Nick Ridley p. 168. **ardea.com:** John Daniels p. vi. **Associated Press:** Steve Parsons/PA Wire URN: 9672876 p. 110. **Caters News Agency:** p. 88. **Cassandra Crawford/Cincinnati Zoo:** p. 35. **Corbis:** Scott Sommerdorf/San Francisco Chronicle p. 135. **Uboldi Emanuele/ubO Photography:** p. 158. **Shaina Fishman:** pp. 2, 3, 150. **Fotolia ©:** Africa Studio p. 56 (hot dog); biglama p. 95; hramovnick p. 120; Eric Isselee p. 69 (bottom left); K.-U. Habler p. 147; Kirill Kedrinski p. 69 (top left); Rita Kochmarjova pp. 14-15, 143; lunamarina p. 70; Michael Pettigrew p. 13; Alexandr Vasilyev p. 69 (top right). **Gerard Fritz:** p. 20. **Getty Images:** AFP pp. 32, 136; Janie Airey p. 50; Martin Barraud p. iii; Mariya Bibikova p. 108; Per Breiehagan p. 82; ©Brooke Anderson Photography p. 58; Cavan Images p. 153; Doug Chinnery p. 64; Compassionate Eye Foundation/David Leahy pp. 92-93; Connie Tameling Photography p. 22; David Conniss p. 8; CountryStyle Photography p. 115; craftvision p. 161; Robert Daly p. 16; Neil Davis pp. 124-125; Shelley Dennis p. 165; dewollewei p. 100; Dana Edmunds p. 62; John Elk p. 60; Tim Flatch p. 11; Jay Fleck p. 34; Fotosearch p. 104; Fox Photos p. 39; Larry Gatz pp. 30-31; General Photography Agency/Stringer p. 142; John Giustina p. 21; GK Gart/Vikki Hart p. 57; iztok noc p. 146; Rosette Jordaan p. 144; Jumpstart Studios p. 9; Keystone p. 7; Krit of Studio OMG p. 74; Catherine Lane p. 160; David Livingston p. 148; Ariane Lohmar p. 56; Marcelo Maia p. 87; MariClick Photography p. 138; Matthew Wilder Photography pp. 116-117; Andrew Olney p. 73; Barbara Peacock p. 130; Lisa Pembleton p. 41; Tim Platt p. 51; Steven Puetzer p. 141; Valerie Shaff p. 97; Jayneboo Shropshire p. 105; Tim Kitchen p. 78; Spangless44flickr p. 103; Tyler Stableford p. 48; SuperStock p. 162; Underwood Archives p. 98; Andrew Bret Wallis p. 24; Emery Way pp. 46, 167. **Istockphoto:** ©fanelie rosier p. 86. **Brooke Jacobs:** p. 90. **KimballStock:** Johan & Santina De Meester p. 154. **Leesia Teh Photography:** pp. 36, 53, 61, 85, 157. **National Geographic Creative:** Joseph Kotlowski p. 113. **Newscom:** Keith Beaty/ZUMA Press p. 47; Kimimasa Mayama/Reuters p. 128. **Redux Pictures:** Alan Poizner/The New York Times p. 27. **Rex USA:** Richard Austin p. 38; Newspix p. 126. **Bev Sparks:** p. 80. **Jason Wallis:** p. 55. ©Warren Photographic: pp. 18, 156. **Paul Wellman:** p. 129.

Courtesy Photos: Rudy Carr: p. 91; **A. Clayton Copeland:** p. iv; **Cynthia Copeland:** p. v; **The Chester L. Hembree family:** p. 106; Intermountain Therapy Animals: p. 133; **Mabel Rothman Collection:** p. 43. **Sarah Lauch:** p. 118; **Oak Hill Animal Rescue:** p. 109; **Wikimedia Commons:** p. 166.